PICTURES OF WAR

MARY GRIFFITHS studied English at the University of Newcastle and Museum Studies at the University of Manchester. She has worked as a curator in galleries and museums since 1989, and is now Curator of Modern Art at the Whitworth Art Gallery, the University of Manchester.

STELLA HALKYARD studied English at the University of Newcastle, History of Art at the University of Manchester, and Archive Studies at the University of Liverpool. Since 1991 she has worked as the Modern Literary Archivist at the John Rylands Library, the University of Manchester.

In memory of George Elwyn Griffiths
1919–1973

PICTURES OF WAR

Mary Griffiths

With an afterword by Stella Halkyard

CARCANET

First published in Great Britain in 2009 by
Carcanet Press Limited
Alliance House
Cross Street
Manchester M2 7AQ

All drawings are height 15cm × width 21cm, except 'Afghanistan, 16 November 2006'
(p. 11), which is 21cm × 29.8cm

A CIP catalogue record for this book is available from the British Library
ISBN 978 1 85754 993 5

The publisher acknowledges financial assistance from Arts Council England

Printed and bound in England by SRP Ltd, Exeter

Contents

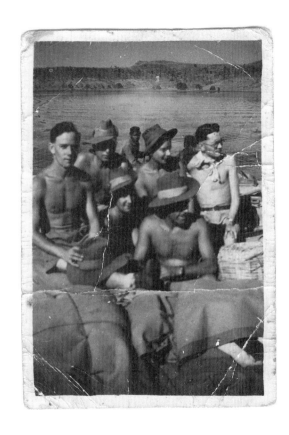

Introduction
Mary Griffiths

There is a photograph of my father travelling by boat in India during the Second World War. Six young men from the 2nd Battalion Manchester Regiment sit amongst their kitbags, their pale northern skin tanned by the sun, except for my father, George Griffiths, whose ashen complexion and emaciated arms show the effects of several diseases including malaria and paralysis that he'd just recovered from before being sent back into action. Two Asian men sit at the back of the boat, not soldiers; one steers the boat away from the shore whilst the other concentrates on a task. In a second image, my father photographs a soldier at the trigger of a Vickers machine gun, firing out of the leafy cover into the fields below. A third photograph (p. xi) shows a Burmese landscape, ground gained by the British in battle. The attack has maimed it – trees are stripped of their branches and leaves, the dry soil is seared. The photographer has focused his camera on a dug-out that Japanese soldiers had been holed-up in. Clouds rise over the hills that sit behind this mockery of a view.

For a man who was conscripted, who hated the war, who woke many nights in terror from his nightmares, and who let a suitcase full of wartime photographs and letters rot in an outhouse, my father left many photographs that still survive: snapshots of his army friends, of him and his brother in their uniforms, of officers looking at maps, Indian cities, battlegrounds. Did he take these photographs to remind himself of what he had seen and done, or was photography simply a way of having something to do in the alternate action and dreariness of war? Were they for his family at home in Birkenhead or for his future children to gaze at?

My knowledge of war began with these photographs, with my father's uniform and his service book, and stories that he'd told my mother and that she told in turn to me and my brothers and sister. We also heard her own stories of the adventures of being a child in wartime Liverpool, the excitement of being in a devastated and confused city. She had been evacuated with her brother to Sandbach in Cheshire, staying with a young couple who had little idea what to do with two children and how to make them welcome. Missing them too much, her tram-driver father turned up one day and took them back to Liverpool. St Charles' School was closed up, so the two children spent the duration of the war playing by the river and docks, and wandering around the craggy shells of bombed buildings. Twenty years after the end of the war, the route of the 82 bus that took me to my grandmother's in Aigburth would pass vast bomb-sites that still held on to some kind of power – their emptiness speaking of the buildings and lives that had been there when my mother was a child.

Our childhood was played out in a big garden that my father had tended beauti-

fully but which had been taken over, after his early death, by his seven children as a battlefield for our own games of war. Underground dens were dug out; fires burned all weekend; warships were made out of scrap wood and old wardrobes; cities were built in the sandpit, to be occupied by plastic armies which were bombed with molten plastic, the firey droplets whistling as they fell onto the houses below. Toy aeroplanes, tanks, mutilated soldiers, were lost or forgotten in the garden. Rusty die-cast tanks and fire engines resurface sometimes when my mother is digging and become part of a bookshelf display.

My experience of the wars that Britain has been engaged in during my lifetime – Northern Ireland, the Falklands, the first Gulf War, and now the wars in Afghanistan and Iraq – has mainly been through the television news. I've known them to be significant but, nonetheless, distant wars, happening to soldiers and civilians many miles away whilst I've been safe in the north-west of England. More than three years into the wars in Afghanistan and Iraq, I realised that the news images of battles, soldiers, ordinary Afghans and Iraqis, roadside bombings, helicopters and tanks, were so numerous that they were passing me by, seen but not noticed. Unlike the total war of the Second World War, and its overwhelming impact on my parents' lives, there I was in the midst of a war that was having no effect on my everyday life. It was then, in a deliberate attempt to see what I was being shown, that I began to make the drawings in this book. I noticed the type of handcart that is common in Iraq and that is often used to moved dead bodies away from a bomb-site; the quiet standing around that seems to follow a roadside bomb; the pick-ups used by the Taliban and the Iraqi police; people going about

their lives; the idiosyncrasies of British Army Land Rovers; cars and people carriers crumpled by bomb blasts; the ways in which radio antennae festoon tanks; the pervasive presence of helicopters.

In 1944, after a period of action in Burma, my father wrote from India to his younger cousins, 'But I won't dwell on these months as they are a very horrible memory and you don't want to hear about these things, and I don't want to refresh my memory.' In these times of wars fought far away but brought into our homes through television, there is a temptation to not want to hear about these things. For those people, soldiers of both sides and civilians, who are experiencing these horrors, all I can do in return is to watch closely and try to be a good witness.

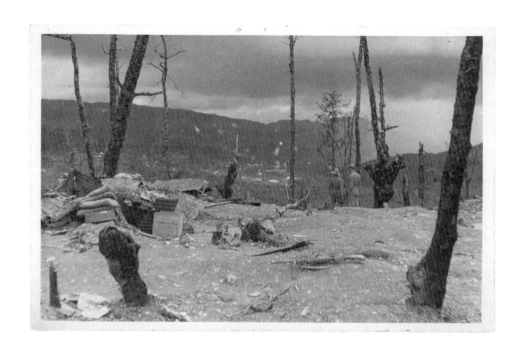

PICTURES OF WAR

Afghanistan 1, 14 November 2006, *Channel 4 News*
Pencil and watercolour on paper

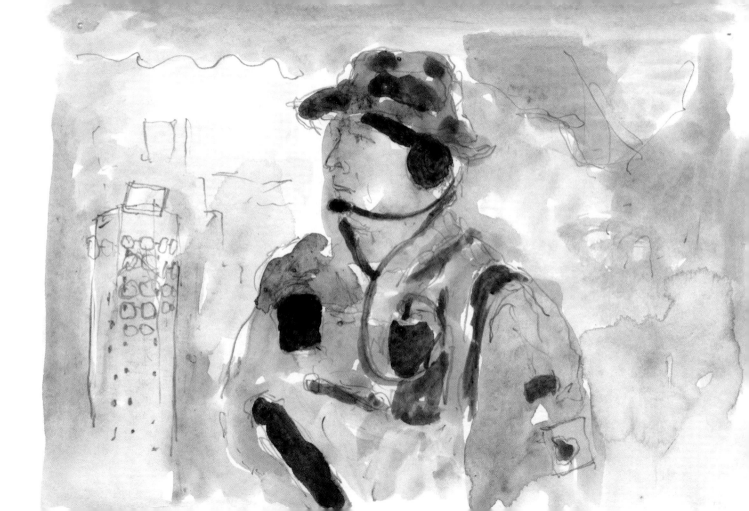

Chinook, Afghanistan, November 2006, *BBC News at Ten*
Pencil, watercolour, pen and ink on paper

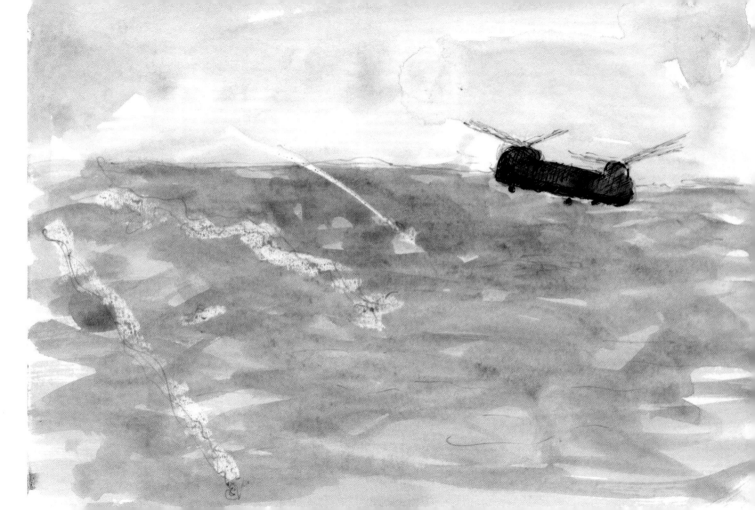

Afghanistan 2, 14 November 2006, *Channel 4 News*
Pencil, pen and ink, watercolour on paper

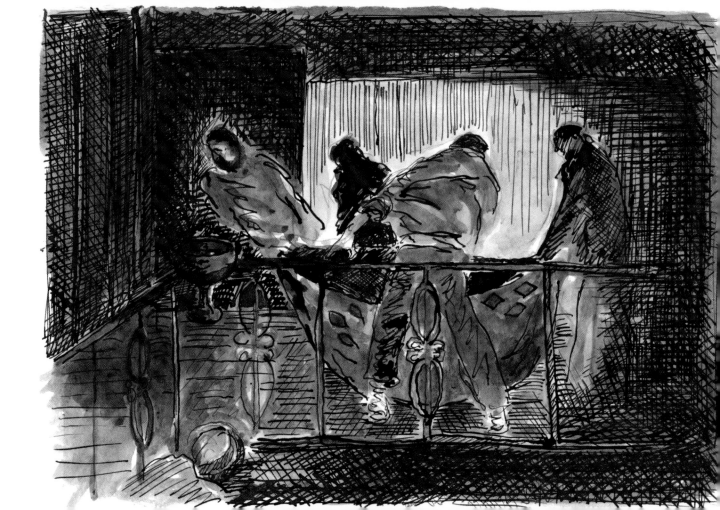

Afghanistan, 15 November 2006, *Channel 4 News*
Pencil and watercolour on paper

Afghanistan, 16 November 2006, *Channel 4 News*
Pencil, pen and ink, watercolour on paper

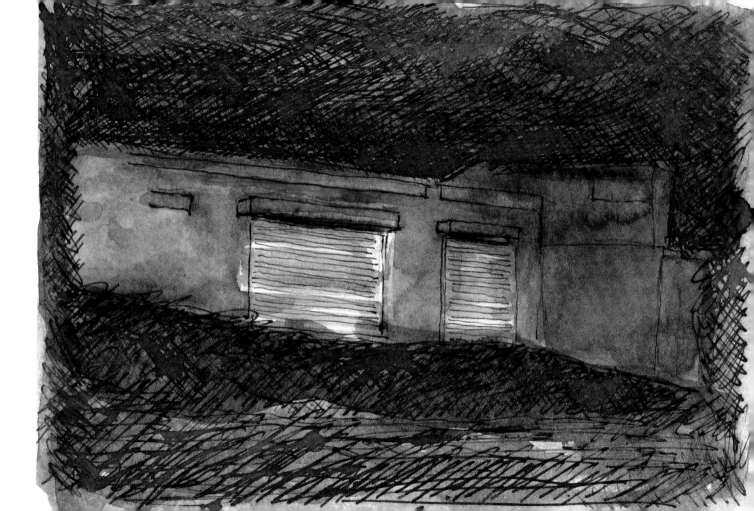

Chair, Iraq, 22 November 2006, *Channel 4 News*
Pencil, pen and ink, watercolour on paper

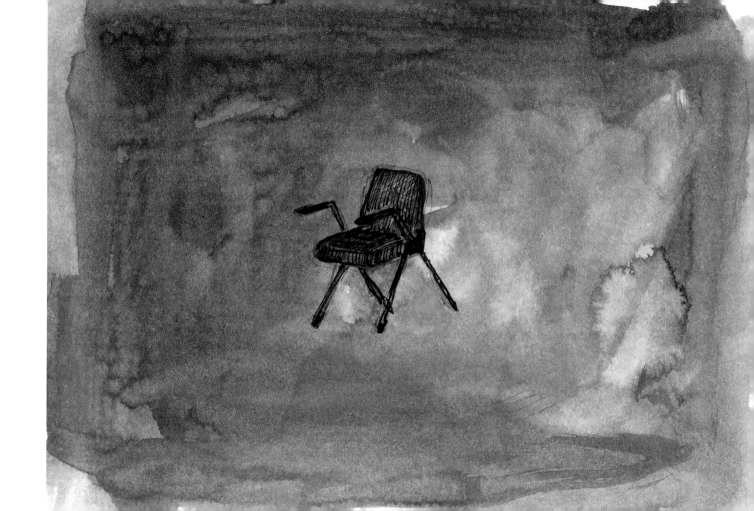

Iraq, 4 December 2006, *Channel 4 News*
Pencil, pen and ink, watercolour on paper

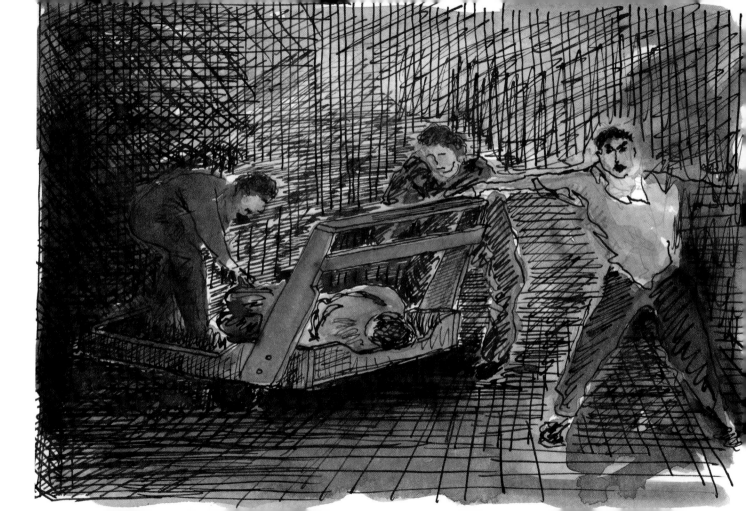

Iraq, 5 December 2006, *Channel 4 News*
Pencil, pen and ink, watercolour on paper

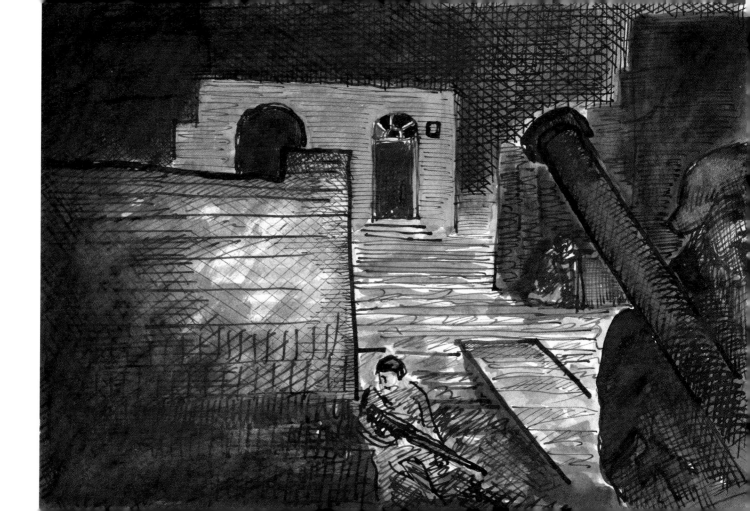

Iraq, 6 December 2006, *Channel 4 News*
Pencil, pen and ink, watercolour on paper

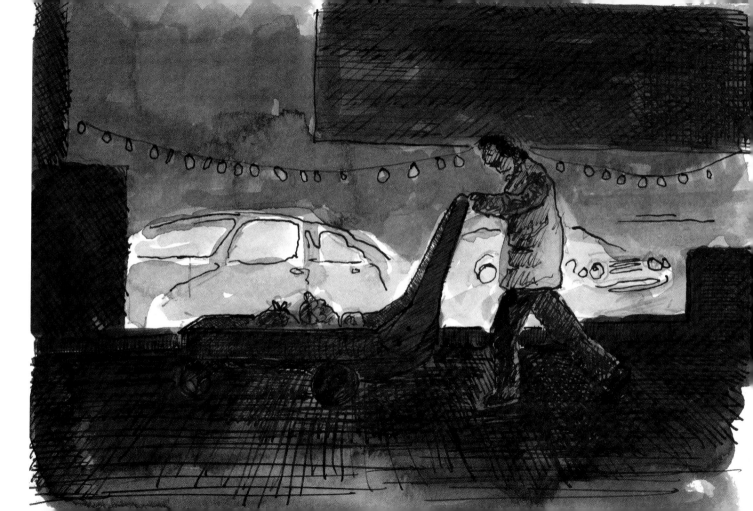

Chinook, Afghanistan, 8 January 2007, *Dispatches*, Channel 4
Pencil and watercolour on paper

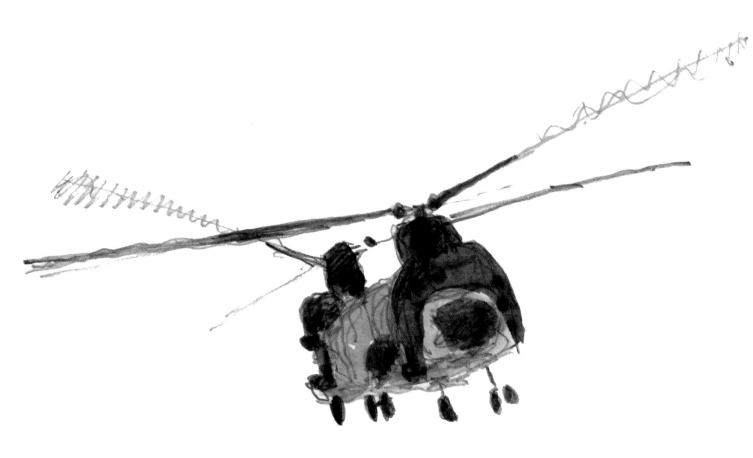

Snatch Land Rover, Afghanistan, 8 January 2007, *Dispatches*, Channel 4
Pencil, pen and ink, watercolour on paper

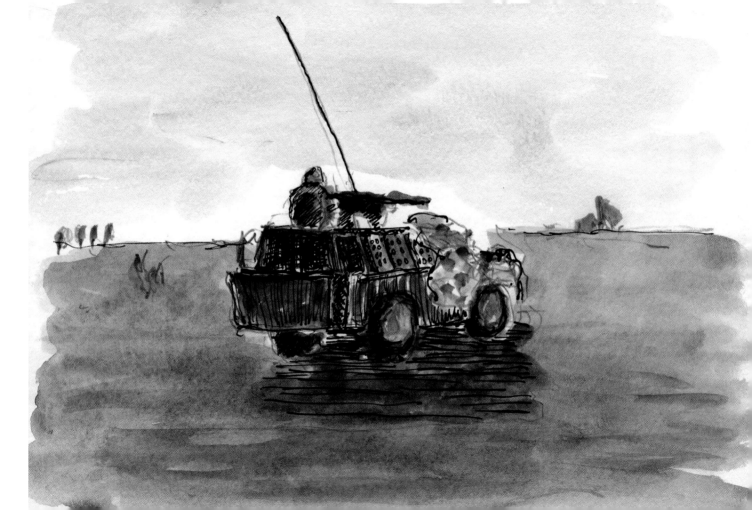

Snatch Land Rover, Iraq, 30 January 2007, *BBC News at Ten*
Pencil and watercolour on paper

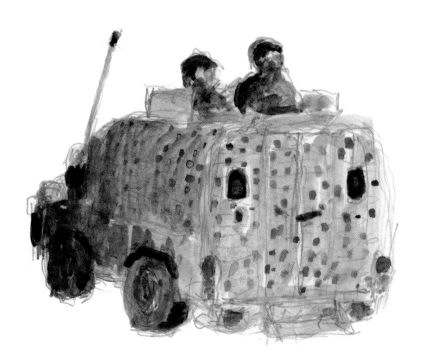

Chinook, Afghanistan, 1 February 2007, *Newsnight*, BBC2
Pencil and watercolour on paper

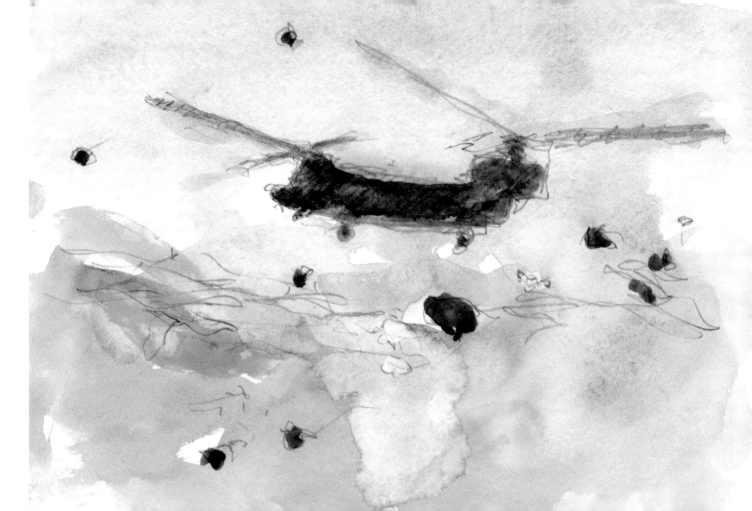

Iraq, 20 February 2007, *Channel 4 News*
Pencil and watercolour on paper

NATO Operations Centre, Kabul, Afghanistan, 28 February 2007,
The Generals' War, BBC2
Pencil and watercolour on paper

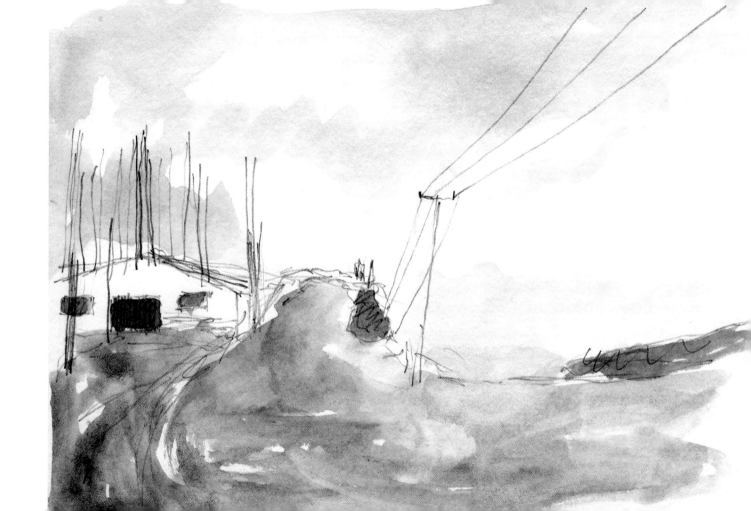

Canadian soldier, Afghanistan, 29 February 2007, *The Generals'
War*, BBC2
Wax crayon, pencil and watercolour on paper

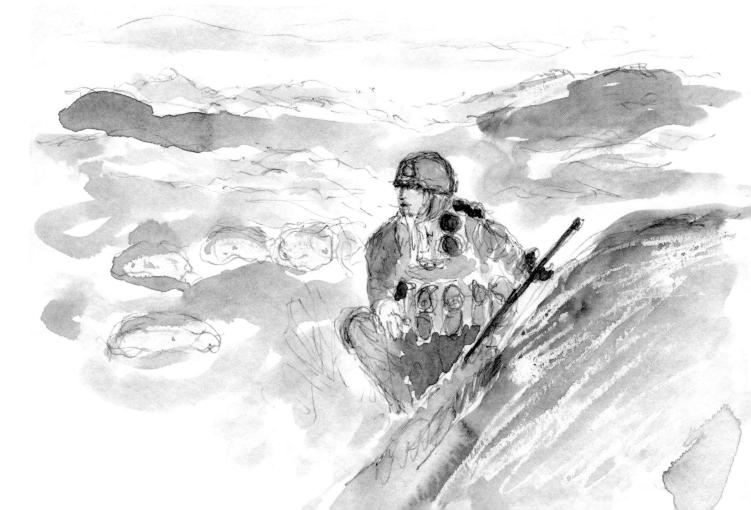

Apache, 9 March 2007, *ITV News*
Pencil and watercolour on paper

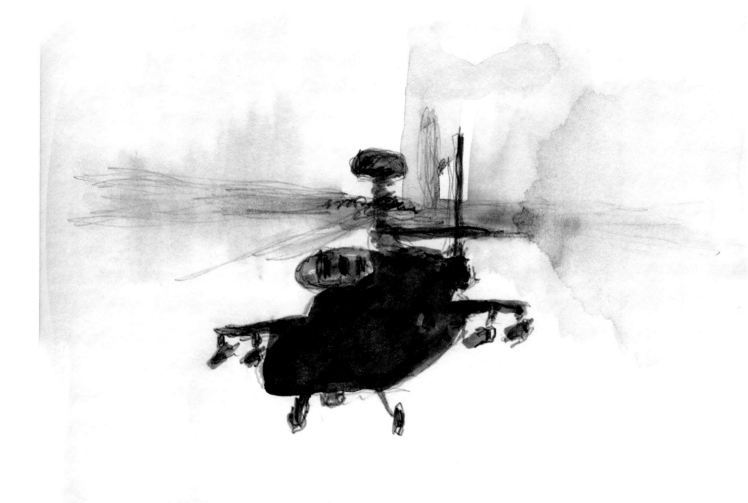

Minibus, Iraq, 19 March 2007, *Channel 4 News*
Pencil and watercolour on paper

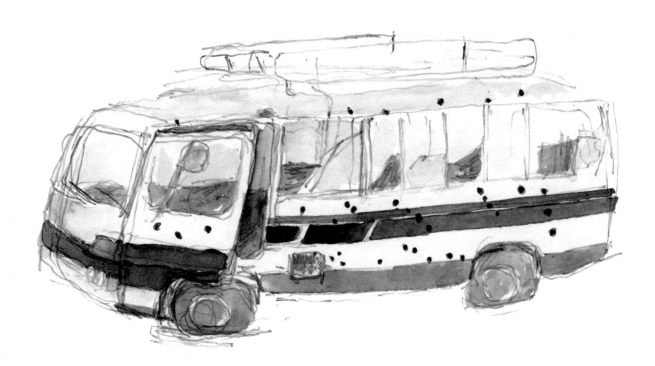

Brize Norton, 20 March 2007, *BBC News at Ten*
Pencil and watercolour on paper

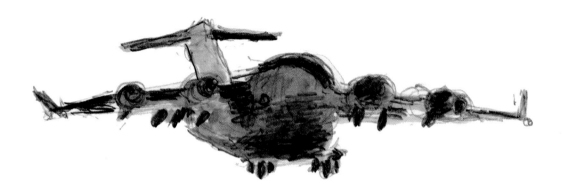

Warrior, Iraq, 21 March 2007, *BBC 6 O'Clock News*
Pencil and watercolour on paper

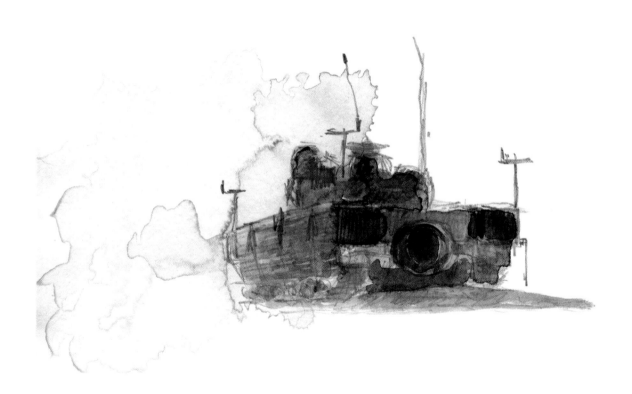

American helicopters, 25 March 2007, *Channel 4 News*
Pencil and watercolour on paper

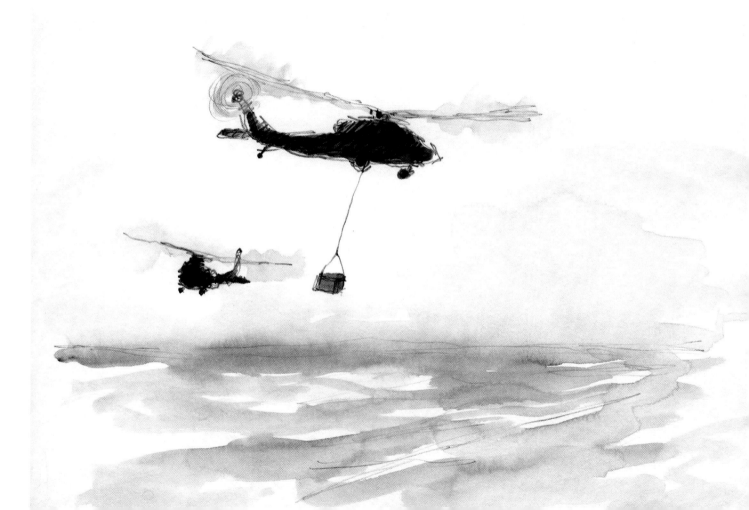

'The roadside bomb that killed them on Thursday…',
8 April 2007, *ITV News*
Pencil and watercolour on paper

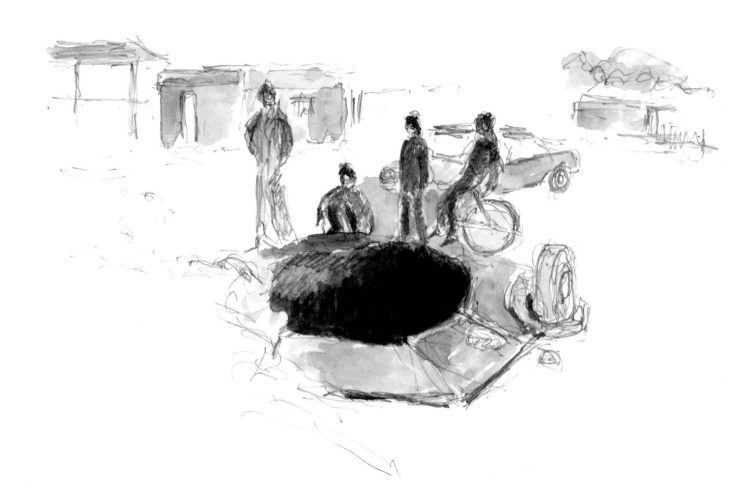

Baghdad, Iraq, 9 April 2007, *Channel 4 News*
Pencil and watercolour on paper

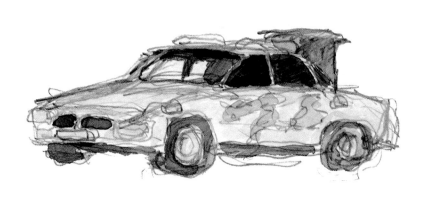

Iraq, 11 June 2007, *BBC News at Ten*
Pencil and watercolour on paper

Afghanistan, 21 June 2007, *BBC 6 O'Clock News*
Pencil and watercolour on paper

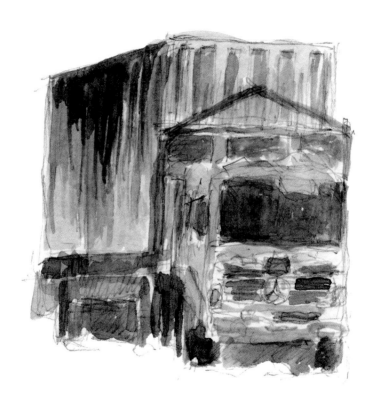

Iraq, 28 June 2007, *Channel 4 News*
Pencil and watercolour on paper

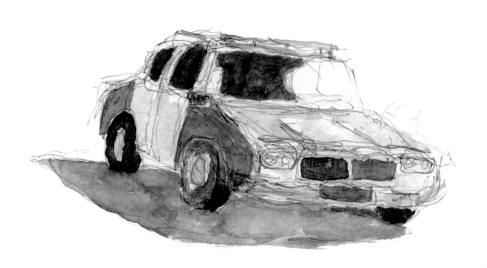

Snatch Land Rover, Iraq, 28 June 2007, *BBC News at Ten*
Pencil and watercolour on paper

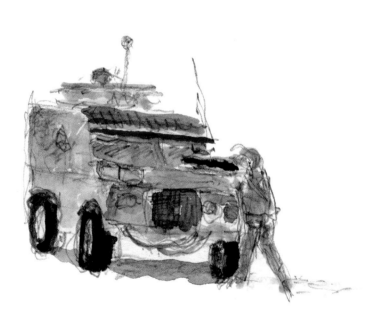

Roadside bomb, Iraq, 28 June 2007, *BBC News at Ten*
Pencil and watercolour on paper

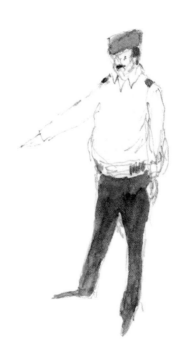

Baghdad bombing, Iraq, 28 June 2007, *Channel 4 News*
Pencil and watercolour on paper

Roadside bomb, Iraq, 29 June 2007, *BBC News at Ten*
Pencil and watercolour on paper

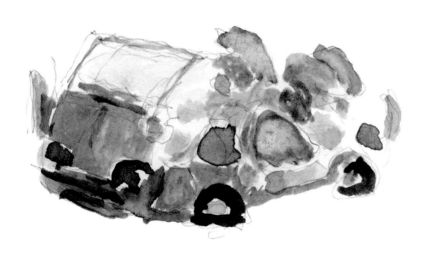

Chinook, Afghanistan, 20 July 2007, *BBC News at Ten*
Pencil and watercolour on paper

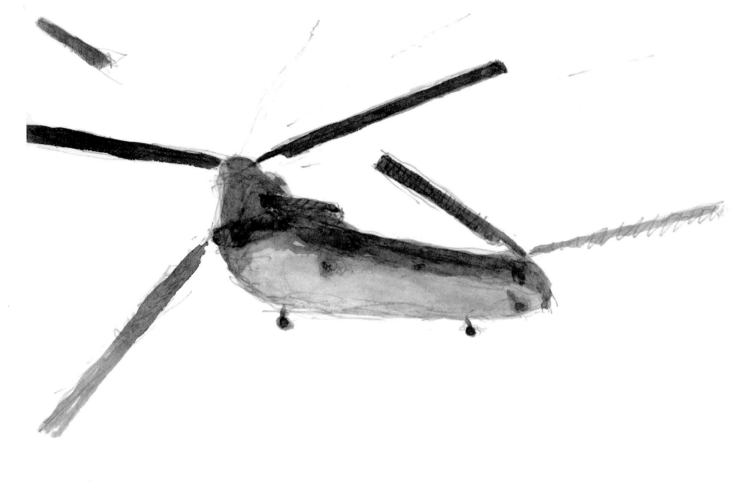

Roadside bomb, Iraq, 1 August 2007, *Channel 4 News*
Pencil and watercolour on paper

Pick-up, roadside bomb, Iraq, 1 August 2007, *Channel 4 News*
Pencil and watercolour on paper

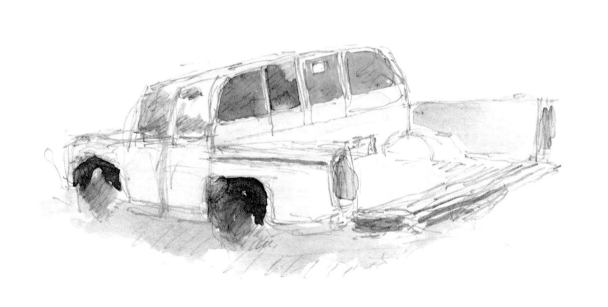

Apache 1, Tura Valley, Afghanistan, 3 August 2007, *Channel 4 News*
Pencil and watercolour on paper

Apache 2, Tura Valley, Afghanistan, 3 August 2007, *Channel 4 News*
Pencil and watercolour on paper

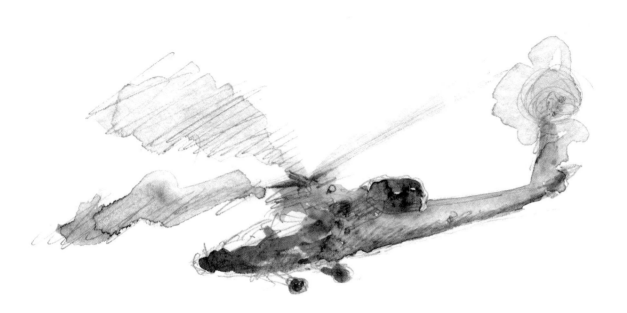

Apache 3, Tura Valley, Afghanistan, 3 August 2007, *Channel 4 News*
Pencil and watercolour on paper

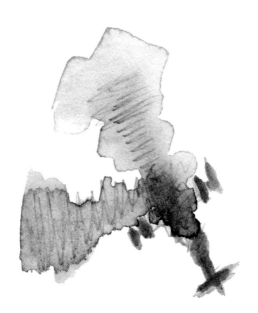

Police car, Tura Valley, Afghanistan, 3 August 2007, *Channel 4 News*
Pencil and watercolour on paper

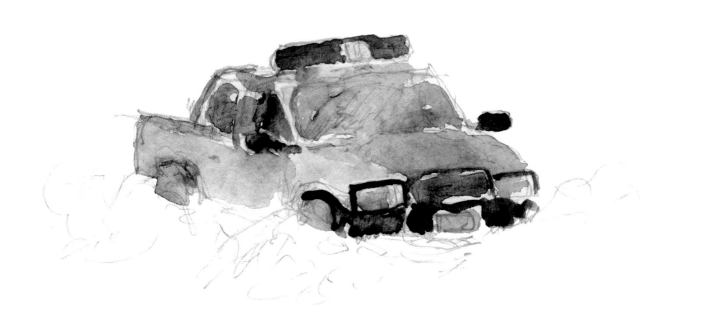

House, Afghanistan, 5 November 2007, *Panorama: Taking on the Taliban*, BBC1
Pencil and watercolour on paper

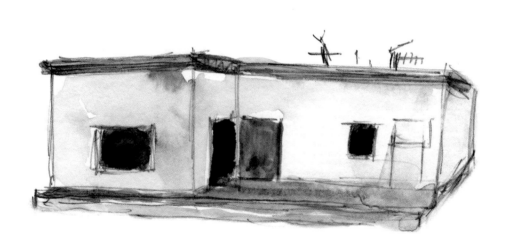

Motor bike, Afghanistan, 5 November 2007, *Panorama: Taking on the Taliban*, BBC1
Pencil and watercolour on paper

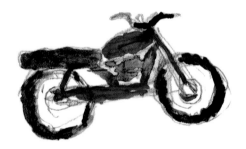

Hercules, Afghanistan, 5 November 2007, *Panorama: Taking on the Taliban*, BBC1
Pencil and watercolour on paper

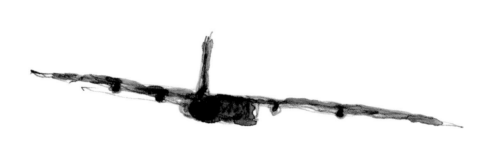

Chinook, Afghanistan, 5 November 2007, *Panorama: Taking on the Taliban*, BBC1
Pencil and watercolour on paper

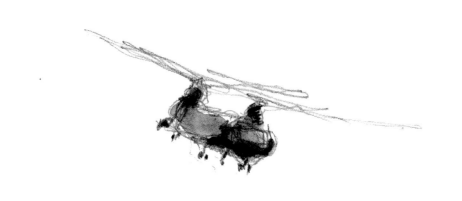

Snatch Land Rover, Iraq, 21 November 2007, *BBC News at Ten*
Pencil and watercolour on paper

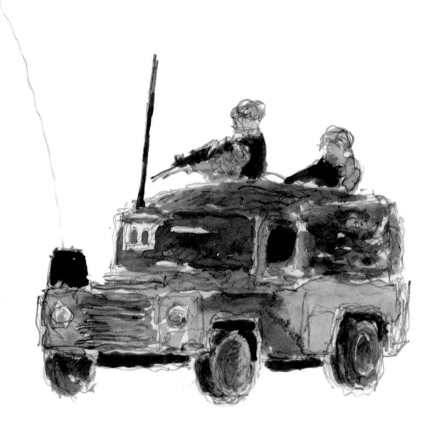

Puma, Iraq, 21 November 2007, *BBC News at Ten*
Pencil and watercolour on paper

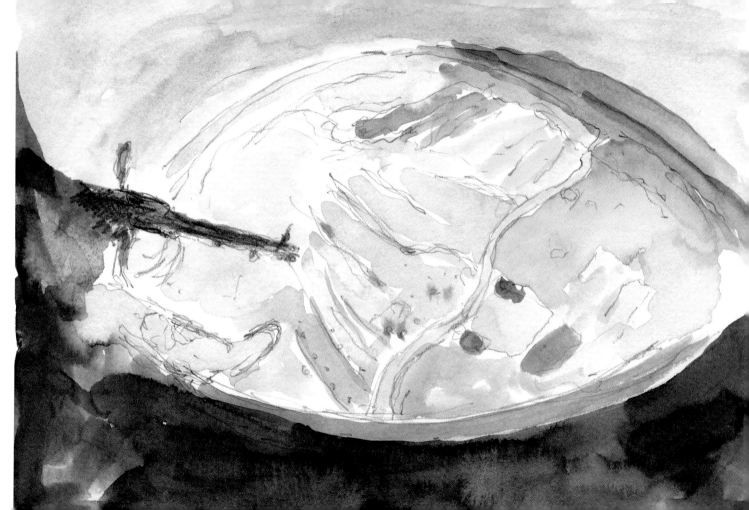

Taliban in police cars, Afghanistan, 10 December 2007,
Channel 4 News
Pencil and watercolour on paper

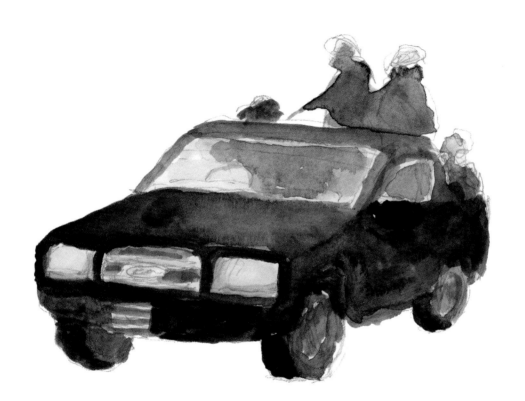

Taliban, Afghanistan, 10 December 2007, *Channel 4 News*
Pencil and watercolour on paper

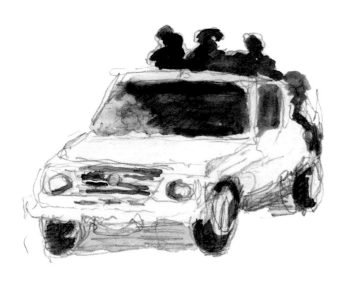

Afghanistan, 10 December 2007, *Channel 4 News*
Pencil and watercolour on paper

Land Rover, Basra, Iraq, 10 December 2007, *Panorama*, BBC1
Pencil and watercolour on paper

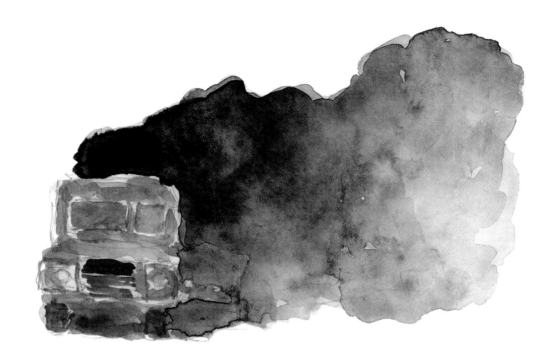

Tank, Basra, Iraq, 10 December 2007, *Panorama*, BBC1
Pencil and watercolour on paper

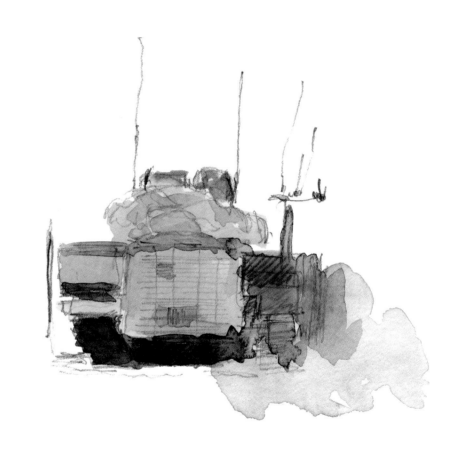

Pick-up, Afghanistan, 30 January 2008, *BBC News at Ten*
Pencil and watercolour on paper

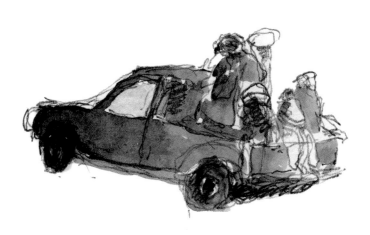

Firemen, bomb-site, 31 January 2008, *BBC News at Ten*
Pencil and watercolour on paper

Afghanistan, 31 January 2008, *BBC News at Ten*
Pencil and watercolour on paper

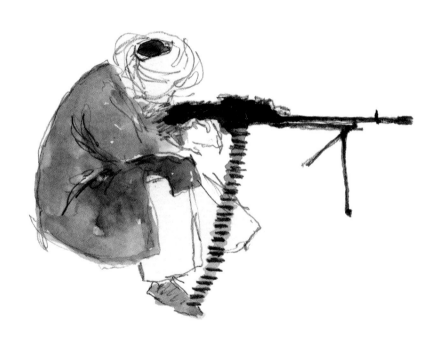

Bomb-site, Afghanistan, 31 January 2008, *BBC News at Ten*
Pencil and watercolour on paper

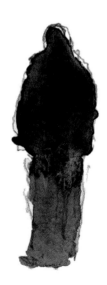

Double bombing, Baghdad, Iraq, 1 February 2008, *BBC News at Ten*
Pencil and watercolour on paper

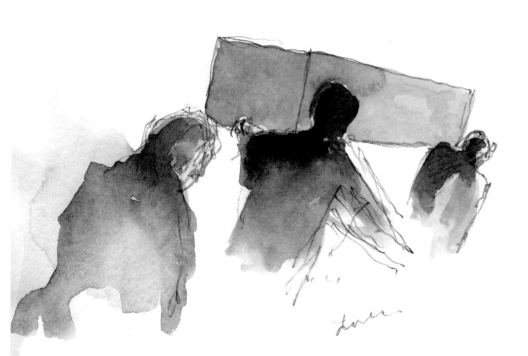

German jeep, Afghanistan, 6 February 2008, *Newsnight*, BBC2
Pencil and watercolour on paper

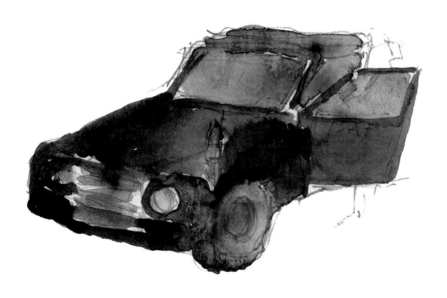

Mutaha Hassan Ali's sixteen-year-old son, Iraq, 19 March 2008,
Channel 4 News
Pencil and watercolour on paper

Soldier dressed as an insurgent, Iraq, 19 March 2008, *Channel 4 News*
Pencil and watercolour on paper

Iraq, 19 March 2008, *Channel 4 News*
Pencil and watercolour on paper

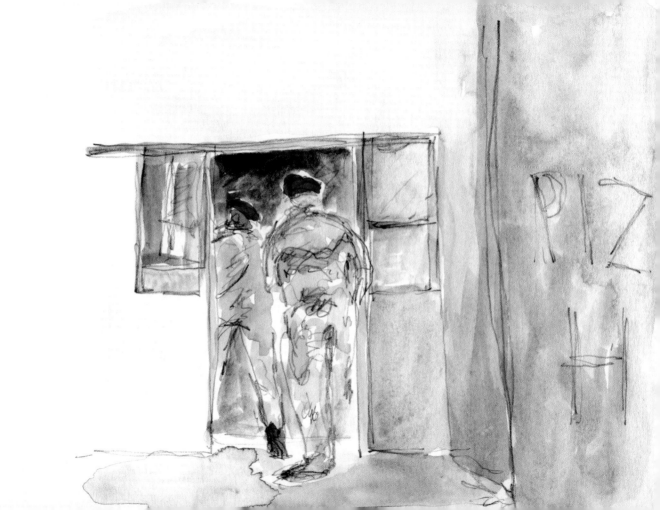

Iraq, 25 March 2008, *Channel 4 News*
Pencil and watercolour on paper

Machti army soldier, Iraq, 26 March 2008, *BBC News at Ten*
Pencil and watercolour on paper

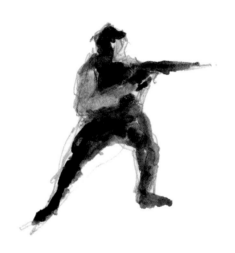

Iraq, 27 March 2008, *Channel 4 News*
Pencil and watercolour on paper

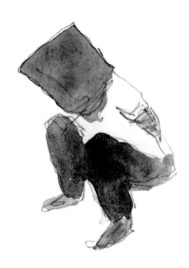

Afterword
Stella Halkyard

A book is a curiosity. On the one hand it is a material object 'occupying numerous sheets or leaves fastened together at one edge … so as to be opened at any particular place, the whole protected by binding or covers of some kind', and on the other it is an abstraction separate from the world of things, 'a written or printed treatise … narrative or account, record, list, register … a literary composition such as would occupy one or more volumes, without regard to the material form or forms in which it actually exists'.[1]

Books are usually the preserve of written texts, and the ancestral habitat of words. Yet, as Roger Chartier reminds us, 'There are also texts that presuppose no use of verbal language: the image in all its forms, the geographical map, musical scores, and even landscape can be considered "non-verbal texts". What authorizes calling these various products "texts" is that they are constructed based on signs whose meaning is fixed by convention and that constitute symbolic systems inviting interpretation.'[2]

Not all the texts encountered in a book are composed of words, since images also reside between their covers. But when images trespass into the domain of the

1 *OED* online version.

2 Roger Chartier, *On the Edge of the Cliff: History, Language and Practices* (London, 1997), p. 81.

word it is customary to presume that the part they play is subservient to that of the written text. As illustrations they can be disregarded, a mere embellishment, their sole function to support the written text to which they defer. Yet this notion of the servile image is deceptive: 'the history of Western culture can in part be seen as the story of a protracted struggle for dominance between pictorial and linguistic signs, each claiming for itself certain propriety rights on a "nature" to which only it has access'.[3] Images exert great power and incite strong feelings.

Yet, confined between the covers of a book, words and images can confront each other in a place where the battle lines between what is 'seeable' and what is 'sayable' shift, blend and sometimes disappear,[4] for images can:

> tell stories, make arguments and signify abstract ideas; words can describe or embody static, spatial states of affairs, and achieve all of the effects of ekphrasis without any deformation of their 'natural' vocation … Language can stand in for depiction and depiction can stand in for language because communicative, expressive acts, narration, argument, description, exposition and so called 'speech acts' are not medium specific … I can make a promise or threaten with a visual sign as eloquently as with an utterance. While its true that Western painting isn't generally used to perform these sorts of speech acts there is no warrant for concluding that they could never do so, or that pictures more generally cannot be used to say just about anything.[5]

So images that inhabit books need not be seen only as 'illustrations' of 'what is

3 Charles Harrison and Paul Wood (eds), *Art in Theory 1900–1990* (Oxford, 1992), p. 1105.

4 W.J.T. Mitchell, *Image [&] Narrative* online version at www.imageandnarrative.be/iconoclasm/gronstad_vagnes.htm

5 'Words and Pictures in the Age of the Image: An Interview with W.J.T. Mitchell' at http://eprints.qut.edu.au/archive/00004620/

already known about … by other means …', they can also be 'independent witnesses, testifying not only to what happen[s] but to the ways in which events [are] perceived and interpreted'.[6]

In the case of this book of drawings of the wars in Afghanistan and Iraq, the visual narrative takes precedence over this written text. These images fight their own battles and they are proof of the picture's power to say just about anything. The function of *these* words is to augment their text by documenting how and why they were made.

6 Michael Camille, *The Mirror of Parchment: The Luttrell Psalter and the Making of Medieval England* (London, 1998), p. 8.

> One thin line of thought in words, not shifting,
> as sands are – well, not quite so shifting, language
> shifts with anchors dragging – must manage
> like a camel-train to make its measured progress
> through the missile banks, camouflage fatigues, gas-masks
> clustered like decapitated insects –
> future ruins already lightly dusted.[7]

7 Edwin Morgan, 'An Iraqi Student', in *Sweeping out the Dark* (Manchester, 1994).

With the waging of the War on Terror in Afghanistan and Iraq in the aftermath of the terrorist attacks of 11 September 2001, a deluge of images showing the obliteration of people, places and things, poured over our screens nightly. We, the civilian population on the 'Home Front', in marked contrast to the peoples of Iraq and Afghanistan, or the 'total war' of the 1939-45 conflict, sat safely, passively watching these disturbing images. Not for us the horror of being sent to find a

mother trying to reach her baby during an air raid or finding her 'hanging over the banisters … her head out open with her brains hanging out … children next door with no arms and legs'.[8]

As days turned into weeks, then months and years, the 'spectacular character'[9] of this relentless torrent of images grew ever more troubling to Mary Griffiths who, sitting in front of the screen of her ancient portable TV, viewed the news footage on Channel 4 and the BBC night after night:

> … and while the world watched, the US invasion and occupation of Iraq … cities that had been under siege, without food, water, electricity for days, cities that had been bombed relentlessly, people who had been starved and systematically impoverished by the UN sanctions regime for more that a decade, were suddenly left with no semblance of urban administration. A seven-thousand-year-old civilization slid into anarchy. On live TV.[10]

These flickering filmic shadows moved too fast for Griffiths to look at them with the intensity they merited. Increasingly, she realised that without seeing them properly she was failing to pay due attention and respect to those people whose stories they told, for 'every image of the past that is not recognized by the present as one of its own concerns threatens to disappear irretrievably'.[11] She needed to 'freeze-frame' this footage to see what was happening and respond to it. Michel de Certeau has noted how contemporary society is characterised by a 'cancerous growth of vision'[12] in which the television viewer 'cannot write anything on the

8 Lynette Roberts, *Diaries, Letters and Recollections* (Manchester, 2008), p. 33.

9 Guy Debord, *The Society of the Spectacle* (New York, 1995), p. 15.

10 Arundhati Roy, *The Ordinary Person's Guide to Empire* (London, 2004), p. 110.

11 Walter Benjamin, *Illuminations* (London, 1992), p. 247.

12 Michel de Certeau, *The Practice of Everyday Life* (London, 1984), p. xxi.

13 de Certeau (1984), p. 31.

14 Raymond Williams, *Politics and Letters* (London, 1979), p. 57.
15 Roy (2004), p. 112.

16 Roy (2004), p. 116.

17 Roy (2004), p. 94.

18 *OED* online version.

screen of his set. He has been dislodged from the product; he plays no role in its apparition. He loses his author's rights and becomes, or so it seems, a pure receiver, the mirror of a multiform and narcissistic actor'.[13]

In privileging sight within the hierarchy of the senses, we should remember that the ocular imperative need not always be passive. Recounting his experience as a soldier in a tank unit in a Second World War artillery regiment, Raymond Williams recalls how the ability to see accurately became a matter of life and death: 'You can't hear anything in these damn tanks because you have got to wear your helmet with the headphones to keep communication. The noise of engines is very high, so you are totally dependent on sight.'[14] Yet within this asymmetric warfare, with its 'grotesque disregard for justice'[15] we are not fighting fascism and life in a tank was not an option for Griffiths, one of the more than ten million people who marched against the war and whose protest was 'disregarded with utter disdain'.[16] Made powerless by this marginalisation, she was compelled to adopt a tactic in her opposition to the dominant orders. In the fog of war we may well be forced to speculate,[17] but the question which came to preoccupy Griffiths concerned the use to which sight might be put. Her need to understand what was happening on the front lines forced her into a re-visioning which resisted the role of a passive spectator, to take up instead that of the non-embedded, active witness. In becoming a witness, it became her responsibility to 'experience by personal (especially ocular) observation; to be present as an observer [to] see with one's own eyes' and to 'furnish evidence or proof [of what she saw through] evidential mark[s] and sign[s]'.[18]

She chose to do this by documenting what she saw through the act of drawing. And in taking up her pencil, paper and paints, it is as if she had determined to respond to the plea of the character of the teacher in Robert Minhinnick's poem 'Voices from *The Museum of the Mother of All Wars*':

Not a page, not a book, not a crayon.
If there was a glass in the window
I would tell my children to breathe a mist
And with their forefingers write what has occurred.[19]

Gradually, she evolved an artistic practice that allowed her to take what she saw, in the way 'many of us in the privileged Western world nowadays see images of war [as] a kind of televisual hyper-reality, a simulacrum'[20] and to transform them into a visual record of events, 'the idea being to give a vivid picture, more than an account'.[21]

But what does it mean to make a record? Taking a leaf out of Griffiths' book, let us 'freeze-frame' this flow of language to consider how, in the case of certain words like 'record', 'tones and rhythms, meanings are offered, felt for, tested, confirmed, asserted, qualified, changed … in a period of change as important as a war'.[22] What kind of a thing, and what kind of practice, is a record? The word 'record', whether in the form of a noun or a verb, has a rich and complex history. It is defined as 'an account of some fact or event preserved in writing or other permanent form; a document [or] monument on which an account is inscribed …

19 Robert Minhinnick, 'Voices from *The Museum of the Mother of All Wars*', in *After the Hurricane* (Manchester, 2002).

20 Katie Gramich, 'Welsh Women Writers and War', in *Wales at War: Critical Essays on Literature and Art*, ed. Tony Curtis (Bridgend, 2007), p. 135.
21 Keith Douglas, *The Letters* (Manchester, 2000), p. 313.

22 Williams (1979), pp. 11–12.

a tracing, a series of marks, made by a recording instrument … a testimony valid as evidence of fact'. As an act, it sets down 'in some permanent form [and converts] sound or visual scenes especially television pictures into a permanent form from which they can afterwards be reproduced by machine'. In one of its more archaic senses, this word also means to 'call to mind, to recall, recollect, [and] remember … to take to heart and give heed to'.[23] In the full resonance of its meaning the term 'record' aptly describes, not only how the images Griffiths created function as things, but also the practice which she developed in the very act of their making.

Yet, by obeying a mimetic impulse in the creation of this record Griffiths was not oblivious to the problematical nature of the 'truth claim' of the documentary mode. As Norman Bryson has observed:

> We need to remember that the lifelikeness (or otherwise) of an image in no way depends on the actual existence of the object being depicted. There can be lifelike and there can be unlifelike representations of angels or gods or Homeric heroes; some representations of unicorns are realistic, others are not. The decision that a particular representation is lifelike entails no existential commitment to the reality of unicorns or angels. Rather, the decision depends on the look of the representation, on how persuasively it creates the effect of lifelikeness – what has been called 'the effect of the real'. The difference between schematic and lifelike images may be resolved, then, not by going out and testing the representation against something in the world (there may be nothing to test it

23 *OED* online version.

against) but simply by considering the way in which the ideal lifelikeness is produced or not produced from within the representation itself.[24]

24 Norman Bryson, *Visual Theory* (Oxford, 1996), p. 97.

Griffiths recognises that her picture-making is encoded with the imprint of her attitudes to the war. For her, '[a]ctuality is the raw material that, as experience, must pass through [her] consciousness … [as a] creative artist to become transformed by labour and in accordance with technical and aesthetic laws into the art product'.[25] In her 'creative treatment of actuality'[26] her purpose is to offer 'an accurate idea of the appearance of things'.

25 Brian Winton, *Claiming the Real: The Documentary Film Revisited* (London, 1995), p. 14.
26 John Grierson, quoted in Winton (1995), p. 6.

Once refined and perfected, the making of these images began to assume an identifiable shape and follow a series of compositional stages. Griffiths made video recordings of news bulletins from the war zones and these recordings soon established themselves as a daily custom. Searching back and forth, back and forth at various speeds, close up to the television screen, she would examine the footage she had captured with scrupulous intensity. As the video recorder fast forwarded and rewound, the spoken commentary of the news report would be rendered mute and, save for the distant irritation of the machine's whirring, she would be able to focus her concentration without distraction upon the sequences of images that spooled past the line of her vision. Intently, she would wait for something to 'flash up in an instant'[27] and catch her eye. When it came, she would stop the film (and the war) and creep her way back to re-find and freeze whatever had arrested her attention within a single frame. If on close examination the image 'spoke' to her, as 'a configuration pregnant with tensions',[28] she would hold it still, in the space of a

27 Benjamin (1992), p. 254.

28 Benjamin (1992), p. 254.

tiny, temporary ceasefire, take up a pre-prepared sheet of A5 paper, in landscape format, and begin to draw upon its surface. In this little window on the world, she would work within the constraints imposed by the medium of magnetic tape, since it is only possible to pause an image on a video for a few minutes. After this, the film automatically springs back into life. The delineation of her chosen image had therefore to be executed with a decisive exactness in order to allow her to transcribe 'just enough' of the essence of the film onto the page as a drawing within the available time. Sometimes abbreviated notes were also scribbled: 'neutral tint', 'Payne's grey', 'greeny-yellow', 'dirty green'; slight indicators whose function it would be to carry the memory of a muddy chromatic across into the next stage of the picture's making. Over a period of eighteen months this ritual would take place nearly every day, and each sitting could produce up to ten images, depending on what Griffiths was able to salvage from the news coverage. Labelled with the dates of their execution and their provenance, these little sketches would then mount up in a stack. The pause in the process of composition marks a shift in Griffiths' creative mode as, using a repertoire of drawing techniques, including watercolour, pen and ink, she would embody the skeleton of each image with colour. In the case of those produced in the early stages of the project, successive washes of watercolour were applied to the paper. Gradually the pencil drawing of the image would be buried beneath them. Built up to produce a shade of burnt coffee, these lakes of colour dried into layers which resemble a landscape composed of arenaceous sedimentary rock deposited in a stratigraphic sequence. As a water-based medium, applied thinly in washes by a brush, and reflecting the light of their customary

paper backgrounds, watercolours are usually associated with the quality of luminosity. Yet notions of colour within the West are culturally significant and Griffiths chose to disturb the radiant properties of the watercolour medium by resorting to an etiolated palette denoting death, with its 'water washes touched up with dribbles of dull yellows and greens, the vile colours of the earth, dirty with human excrement and the dust of generations … carefully constructed to appear as dead and sickly as its subject matter'.[29] The colour of the grubby yellow coats of firefighters in the image dated 31 January 2008 (p. 101) reappears shortly after in the image dated 1 February 2008 (p. 107) on a coffin carrying the dead.

Griffiths also uses the formal properties of her watercolours to subvert some of the decorous expectations of class and gender historically associated with this medium within 'English' culture. The use of watercolour, in the well-bred hands of genteel ladies, has usually signified feminine accomplishment rather than being, as here, a means of creating a visual exegesis, by a working-class woman, on the power of modern weaponry. Also, in their dissecting of what Keith Douglas described as the 'Anatomy of Battle', these troubling little paintings disrupt notions that present the world of the miniature as a 'monument against instability, randomness and vulgarity' and a safe haven from the flux of lived reality.[30]

In the earliest images, Griffiths' task was to excavate the revenant spectres of the figures and objects delineated beneath the layers of tint, with pen and ink, to produce a record of lapidary verisimilitude. In the case of the painting dated 14 November 2006 (p. 7) for instance, the filigree of a balustrade, the shadows falling on an urn and the diamond patterning on the rug which is being used to carry the

29 Michael Camille, *Master of Death: The Lifeless Art of Pierre Remiet* (London, 1996), p. 65.

30 Susan Stewart, *On Longing: Narratives of the Miniature, the Gigantic, the Souvenir, the Collection* (London, 1993), pp. 62, 65.

body of a person caught in crossfire, are minutely captured. This precise cherishing of the particular would have appealed to the speaker in Alun Lewis's poem 'Embarkation', a witness from another war, for whom it was the case that 'some things you see in detail, those you need'.[31] This need to produce a richly textured record catches not only the action in the scene but all of the happenstance details, the overlooked objects which speak of the patina of the life held within the frame of the image. This refers back to the footage caught by the television camera, part of the prehistory of Griffiths' drawings. In one sense these images have been meditated and edited by the living subjective eye/I of the person operating the camera. As Paul Rotha observes, 'The way in which a camera is used, its many movements and angles of vision in relation to the object being photographed, the speed at which it reproduces actions and the very appearance of persons and things before it, are governed by the many ways in which editing is fulfilled.'[32]

Yet it is also the case that in some senses the magisterial, scopic sweep of the 'eye' of the television camera, voraciously and indiscriminately, transcribes everything in its wake only for it to be lost to the viewer in the showing of the footage in 'real time' on the screen.

Griffiths' initial response to the images she was able to snatch from oblivion was to preserve them in their totality as part of her visual record. However, her technique changed noticeably, though gradually, through time. About 150 images in total were produced between November 2006 and March 2008. Scrutinising the television coverage through her drawings, Griffiths realised, long before the return of the troops, that the footage was being recycled. Reappearing like a ghostly

31 Alun Lewis, 'On Embarkation,' in *Collected Poems* (Bridgend, 2007).

32 Winton (1995), p. 25.

apparition. As far as the artist was concerned, these jaded images had lost their power to say almost anything and had reverted to mere illustration, precipitating her prompt withdrawal.

Of the sixty images Griffiths selects here, twenty favour a forensic technique, while in those which make up the remaining two-thirds of the book she has developed a very different aesthetic. By using chronology as the organising principle for her images, Griffiths makes the shift in her practice explicit. It has become an integral part of the narrative embedded within the very structure of the material fabric of the book. This sequential ordering and inherent linearity suggest the movement of television footage whose construction these accumulating images resurrect in relic form.

In the later drawings, Griffiths chooses not to build up the backgrounds with washes of watercolours or exhume their underlying drawing and lavish them with an opulence of detail in pen and ink. Instead, she leaves the background of the paper blank and, using pools of watercolour, begins to 'colour in' her pencil lines. Singled out, soldiers, guns, tanks, helicopters, pick-up trucks peopled with Taliban fighters, victims of executions and civilians in stripy shirts, are evoked concisely in faint lines and puddles of tint. These slight, tiny fragments are cut adrift, then left to hang in the solitude of an uninhabited landscape.

In the image dated 10 December 2007 (p. 97), for example, a tank advances, its monumental hulk menacingly oscillating in the heat. The earth quakes beneath as it throws up clouds of suffocating dust. Caught in the lines of its tracks and the

33 Keith Douglas, '.303', in *Collected Poems* (London, 1951), p. 125.

34 Douglas, 'Cairo Jag', in *Collected Poems* (London, 1951), pp. 27–8.

35 Williams (1979), p. 56.

36 Williams (1979), p. 57.

sights of its machine guns, there is no means of escape. In the world outside the tank, '[wo]men curse, weep, cough, sprawl in their entrails':[33]

> the vegetation is of iron
> dead tanks, gun barrels split like celery
> the metal brambles have no flowers or berries
> and there is all sorts of manure, you can imagine
> the dead themselves, their boots, clothes and possessions
> clinging to the ground...[34]

For those inside, things are little better. During the fighting, 'confined within this little metal interior of the tank surrounded by hundreds of rounds of high explosive ammunition and a considerable quantity of diesel fuel', they live with constant fear for if they get hit 'it' is 'instant'.[35] Even for those who manage to evade 'it', there is ultimately no escape. As Raymond Williams insisted when asked about the effect which war had had on him:

> I don't think anyone really ever gets over it. First there is the guilt: about moments of cowardice, but also about moments of pure aggression and brutality. Are these really opposites? It is easy enough to feel guilty about when you felt frightened but much worse is the guilt once you've started recovering your full human perspective, which is radically reduced by the whole experience of fighting.[36]

In their art of making, these images rely upon the presence and involvement of the reader-viewer who is invited to enter in and dwell within their landscape. Unlike de Certeau's television screen, this seeming empty space teems with imaginative possibilities and creates an oasis on the fringes of the arid desert of the spectacular. Through active participation in making the meaning of these works, the reader-viewer 'combines their fragments and creates something un-known in the space organised by their capacity for allowing an indefinite plurality of meanings'.[37] In doing so, they too might reclaim some of their author's rights '[a]nd with their forefingers write what has occurred'.

37 de Certeau (1984), p. 160.